Rumzi K.

A Lifelong Love Affair

From Ramallah
to New Haven
and the Artistry
of Persian Rugs

RUMZI
KAOUD

Dedicated to my family—my late wife Salwa,
my son Jimmy, my grandchildren RJ, Jillian, and Joey,
and my daughter-in-law Kristina.

To Mr. Taborian—for hanging his colorful rugs
on his balcony.

To the weavers—thank you for the magic.

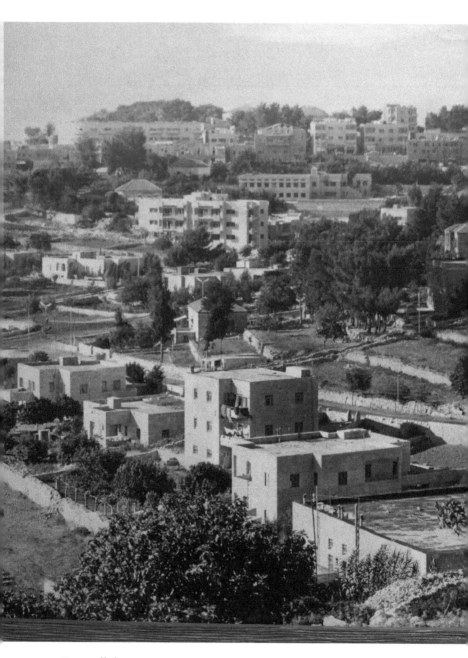

Ramallah, circa 1950

I WAS BORN IN RAMALLAH, PALESTINE, A VILLAGE OF 3,000 people who were Christian and interrelated. The town was beautiful, enjoying temperate weather as well as bountiful fruit trees and vegetable gardens. Ramallah was the cultural center of Palestine, with an elite private Friends School that was sponsored and run by American Quakers, Birzeit University, first-class hotels, two movie theaters, clothing boutiques, ice cream parlors, and restaurants. It also had beautiful apple orchards, fig trees, grape vines, and olive trees. We had an elected mayor and a board of selectmen. There were organized traffic patterns, wide sidewalks for pedestrian walkways, and civilized zoning. There was also a police force and hardly any crime.

We were eight total in my family, with six children as well as my mother and father. My father was a stonecutter and mason who worked every day,

summer and winter, bringing his pay home to my mother, who also worked very hard taking care of the well-being of the family.

I remember there was a field of fig trees. In the summer, I used to see nomads coming and pitching goat-hair tents and staying for a short while. They were very poor. One time, when I was eight years old, I became curious to see how they lived. What I saw was a mother with her baby on a piece of cloth on the ground. It made me feel bad, so the next day—without telling my mother—I took a loaf of bread and a jar of white cheese in salted water (so the cheese would last) to the tent and gave it to the mother. That is a strong memory.

I went to public school until sixth grade, and then I transferred to the Friends School, which had been opened by the Quakers in 1850. The school was staffed by Americans, both the teachers and the principal, and it had high standards. One had to pass fourteen subjects with a mark of 65 or above to graduate. When I graduated in 1957, I was captain of the soccer team. The Quakers instilled in me a work ethic and the notion that truth and honesty ruled supreme.

There was a Masonic temple in Ramallah that was used for different functions. One Easter holiday, the Baptist church reserved the theater for a reenactment of the Crucifixion of Christ. At fifteen years old, I looked older and more mature, and I was chosen by the director to play the main role. I accepted it, and I acted the best I could. I remember after the play was over walking toward the exit and being amazed at people crying with real tears and congratulating me. I was really taken by it at that age.

The Masonic building was always there for community events. Once a week, myself and Cynthia Perdue (a Baptist missionary who married Jad Michael and lived in Ramallah), along with Dr. Daoud Michael (Jad's brother), volunteered to treat the sick people who walked to the temple from miles away. My job was to bring to the doctor the sickest people first for treatment. We gave free medication to some, and to others we gave prescriptions or verbal advice. Once Daoud checked all of them, usually by midafternoon, we would close the temple and go home.

Jad and Cynthia were active in the First Baptist Church in Ramallah. The church had Sunday service with a minister by the name of Reverend Zugg. On some Sundays that he was absent, I was chosen as a substitute to give the sermon. On one such occasion,

the hall was full of mostly elderly people, and I read for them a chapter from the New Testament and elaborated about it. I ended the sermon with a prayer and a hymn that we sang together.

After school, and through summer vacations, I used to work at the pharmacy to help make some money to pay for my private schooling. I did not want to lean on my parents for money. At that time, the pharmacist started importing drugs from an American company called Merck, Sharp, and Dohme. The pharmacist asked me to represent the company and take samples of drugs such as chlotride, cathomycin, and others on visits to the doctors in Ramallah. I would explain the features of the drugs and leave samples so that they would prescribe them and refer their patients to our pharmacy. Having a curious mind, I enjoyed the work and the exposure to doctors.

Our family home was a very nice house with arched windows and hand-cut stones in a very nice setting. Across the way was another very nice house where an Armenian family lived. They

had beautiful handmade rugs. The father used to air them out on a balcony—it was a beautiful scene. It turned out he was a dealer of Persian rugs, with a small store opposite the Church of the Holy Sepulchre in Jerusalem. When I was a young boy, I used to take the bus to Jerusalem (it's about eight miles from Ramallah) and visit Mr. Taborian, our neighbor. I was fascinated looking at and touching those beautiful rugs made by villagers in Persia. The villagers who wove those beautiful rugs continue to inspire me and speak to me to this day.

It was a good life, in a town with little crime to speak of. For the first twenty years of my life, I did not see in Ramallah a McDonalds, Burger King, or Kentucky Fried Chicken.

Because of our proximity to Jerusalem, we used to have many American tourists come to Ramallah to take in its beauty and Christian culture. In return, people from Ramallah were fascinated with American culture and every aspect of American life. My grandfather was one of them. He left his three young boys and his wife, got on a ship in Jaffa, and came to America in 1890 looking for work to support his family back home. He used to go from house to house selling artifacts from the Holy Land. There was a store in Brooklyn owned by a Palestinian where people

like my grandfather would go to consign things and return to be paid for the items that they sold.

More and more people from Ramallah immigrated to America to try to make a few dollars to send back home. In time, when they were confident enough, they brought their families to America. That was the proud moment of their life, coming to America. My grandfather followed this path, and eventually my father and two brothers moved to New Haven, Connecticut. They settled there because I had a great-uncle who had been established there since about 1850. I stayed in Ramallah until I graduated high school; then I came with my mother and younger brother to join the family in New Haven. That was 1958. I was twenty years old.

When I arrived in New Haven, I was amazed at the amount of infrastructure in America. There was such a massive amount of engineering needed to have an orderly society living in a city, with civil laws organized for safety and efficiency in the roads, sidewalks, traffic lights, exits and entrances

to highways, etc. The city government applied zoning laws so that homes were safe to live in, with a fire department and police department ready to assist. I saw this was a very organized society that took a lot of sweat to create. I encountered first- and second-generation Americans, along with people here for many generations.

Upon my arrival, my father asked me what college I would like to go to. I thought about how I had made the decision to move from the public school to the private Friends high school, where I spent four years. It was a rigid school environment; I didn't want more of that. Then I thought of those beautiful rugs in front of the Church of the Holy Sepulchre in Jerusalem. So I told my father I wanted to go into the family rug business. He said good luck to you.

So I started my studies of the business aspects, the rules and regulations and business laws of the state of Connecticut. But this was 1958, when the Vietnam War was in its infancy. At that age, I wanted to experience the military life, and I was advised to join the National Guard. I was sent to Fort Dix, New Jersey. There, I did basic training with about a hundred other recruits, mostly from New England. When the examination time came, the commander sat us in a large hall to take a written exam so as to know where

each one of us would be placed, whether on kitchen duty or guard duty and so on. According to the results of the test, I was placed in an intelligence-gathering company, the 243rd Signal Battalion. I was stationed at Fort Slocum, on an island near New Rochelle, New York, where I did my six months of active-duty training on how to gather intelligence on the enemy. I enjoyed this very much, and after that I was in the reserves for two and a half years. It's a valuable experience to be trained by highly disciplined military personnel from all over the United States and to have interaction with a multitude of cultures and habits.

Once I returned to New Haven, it was back to the family business. I was like a kid in a candy store, learning from the ideas of older and more experienced businesspeople. I was overwhelmed with their kindness and their will to assist. I spoke English well, but I still couldn't absorb all the American greatness in such a short time. I kept experiencing pleasant surprises as I got to do business the American way. For me, it was like going to college, but I was having

my classes on Main Street: every day a new subject to learn from a different source.

This country known as the United States of America is a God-given blessing for every inhabitant who lives here. My grandfather left three young boys and his wife and traveled to America, and it speaks volumes for his courage to leave everything behind and come to a place with an unknown environment, language, food, and culture—ready to work to send back money to feed his family. He was physically and psychologically strong, as have been the millions of others who have made that adventure.

We had business cards printed with our names and started knocking on doors. I used to pick big houses, mainly in New Haven, where I would introduce myself and say that if they needed Persian rugs, they could call me and I would accommodate them. I also went to some Yale University buildings and did the same. Six months went by, and then we started getting phone calls for cleaning and repair, and some sales.

We rented a storefront on State Street in New Haven and had a display of rugs on consignment and wall-to-wall samples for carpeting. I had come from a village in Palestine right to the shadows of Yale University. I was extremely happy and appreciative.

I thought of myself as an immigrant even though my father was in New Haven and my grandfather had immigrated to the United States in 1890.

In 1962, I was recommended to the head designer at Yale, who called and asked me to meet her at 1 Hillhouse Avenue in New Haven, at the time home to the president of Yale, Alfred Whitney Griswold. The house was full of beautiful Persian carpets. The designer told me the president and his family go to Martha's Vineyard every summer and asked if while they were away, I was willing to go into the house and go over the rugs and do whatever needed to be done as to cleaning, repairing, moth-proofing, or replacing them. I agreed, very impressed with how word of mouth was the rule in the trade culture in America.

As I immersed myself in the rug business, my connection with Yale University and its professors, students, and employees grew. It seemed to me so valuable to live near this most humane institution that attracted the highest intellects on the planet. And of course, a certain number of graduates decide to stay in Connecticut and marry and establish a family, with that varied intellect increasing and enriching the local societies. I hope the people of Connecticut realize that they have a most valuable gift in their life with Yale University.

So life became interesting and stimulating living in the shadows of Yale. It was quite an experience for a Ramallah boy, moving from a Palestinian village to the awesome power of Yale University. The products we were handling—Persian rugs made by villagers of the Caucasus Mountains—were loaded with talent and creativity, which fit perfectly with the Yale intellect.

We were outgrowing the store on State Street, so we rented a 5,000-square-foot building on Orchard Street, a very convenient location, and bought automatic cleaning equipment from Germany. We were doing very well and started importing rugs from Iran, the largest producer of Persian carpets (Turkey is the second largest producer). We worked very hard and kept investing in the business.

In 1964, I returned to Ramallah to get married. It was a semi-arranged marriage. I knew of my future wife growing up, and I had seen her as a teenager. Not only was she top of her class in school, but she was also the beauty queen of Ramallah. After marrying I returned with my wife, Salwa, to New Haven.

The type of products we sell, handmade rugs, have complex merchandising features. The sizes and designs are varied and hardly any two are alike. The colors are all different and the qualities are different. Even the wool used comes from a variety of sheep, with the best coming from higher elevations, where the sheep live in a cooler temperature. Here the wool grows longer to keep the sheep warm during the winter.

The best wool for a handmade carpet is sheared when the wool is at its longest, after the farmers have been combing it every night so it has a long staple. (A staple is the length of the filament of yarn before shearing—the longer the better.) They then spin it using a stone for weight: They tie the start of the wool to the stone and spin the stone standing up, so while the stone is spinning they can lengthen the wool thread by using their fingers, spinning the thread from the wool fluff. As the stone reaches the ground, they hold the stone and wrap the wool thread around it tightly, until the size of the ball is what they want. Then they cut the thread and keep the ball tight for a long time, until they are satisfied that the yarn is set in a permanent twist. So, they look for the longest staple before they shear the wool and then create the tightest spin they can produce.

That process is primitive, but it makes the best wool yarns on the planet for use in carpets. Wool has a memory of 300 years, meaning it will stand up and be resilient for that period of time. In contrast, synthetic yarn has an average memory of five years, after which it will droop and die on the floor and forget what it was created for. The best wool will stand up to abrasion and wear for the longest time of all the fibers. Silk is the strongest fiber known, which is why it is used for parachutes; that is all well and good, but silk does not have anywhere near the stamina of wool. Wool filament is a tubular shape with a hollow core similar to a straw.

Carpet-weaving knowledge has been passed down from one generation to the next in villages in the Caucasus Mountains, in parts of Iran, Turkey, Armenia, and Azerbaijan. The procedure for dyeing rugs is also very involved and required the villagers to go into the fields to collect flowers, plants, roots, shrubs, fruits such as pomegranate, all kinds of berries, tree bark, and more. For dyeing the yarn with happy colors, each bundle of yarn is boiled in a kettle for a certain amount of time and then dried in the sun, and then the excess residue washed off.

The villagers live a wholesome life. They farm the land and build their homes from tree branches

and mud and straw. The village culture is not about fancy homes but, rather, the gathering of the family. So their interest and value is in human beings rather than material things. Those villagers' phenomenal talent in the arts is most likely passed genetically from one generation to the next. They are not into science, but their brains are overflowing with artistic talent and creativity.

The weaving process is where every strand of wool is knotted by hand on the warp, which is the cotton or wool that has been plied to withstand the pressure of hand-knotting. This is done mostly in an upright loom made from specially chosen wood branches that are straight and hung horizontally one above the other and adjusted for the length of the carpet. The knotting starts from the bottom, with the first row across the width of the carpet. After the first row is done, then comes the weft, which is zigzagged through the strings and pushed down with a steel comb to lock the knots into place. The second row has the same application, and the process is repeated

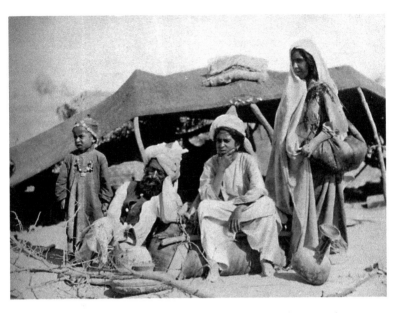

The village culture is not about fancy homes but, rather, the gathering of the family.

until the knotting is done to the top row. Then the weaver cuts the upper cords and the carpet is opened onto the floor and sheared and finished by hand, sides and ends.

There is no machine known to man that can weave by knotting the same way. People ask why hand-knotting is better than machine weaving. The answer is that this process is uniquely suited to carpet construction because the wool yarn is upright and sits on a bed of wool knots as a base, which cushions the impact downward, as when it is walked upon.

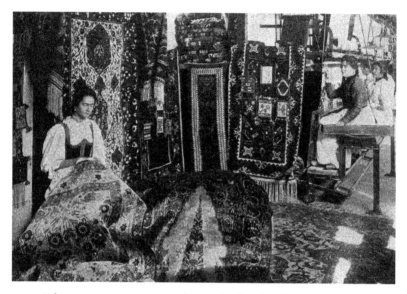

The carpet-weaving knowledge has been passed down from one generation to the next in villages in the Caucasus Mountains, in parts of Iran, Turkey, Armenia, and Azerbaijan.

And that support prevents the upright-standing tufts from getting crushed and matting, so the sides of the upright tufts are protected from walking abrasions. They stay upright because of the foundation support from the wool knots that are tied in place. This method of weaving carpets takes five years for a room-size carpet, but that carpet could last in a home, with moderate use, for about 150 years.

Designs and colors are just as important as the weaving that is done. These properties are of the greatest value to those who purchase and live with these carpets every day without tiring of them. The designs are mostly in two categories: floral designs and geometric designs. Floral designs are conceived from the flower pockets in and around the village where the rug is created. These gardens are seasonal, just two months of the year, while the rest of the year the landscape is set in the so-called earth tones, which is very monotone. Inspired by these flowers, the artistic talent comes alive and overflowing in the creative portion of the rugmaker's brain. They create a garden in the carpet that is used all year to compensate for the earth tones outside. They design the pattern mentally, thinking about the type of flowers they want to use and the arrangement, all in a room-size carpet.

These village craftspeople know that humans move in a circular motion; gatherings of four or six people do not stand on the floor to make a square or rectangle. The groups tend to stand facing each other, in a circle. The weaver-artist is aware of this circular

motion when he plans the flower arrangement on the carpet. He also knows that when planting a flower bed in the village, the first task the gardener does is make a border with stones to outline the area in which they intend to plant the flowers. This is why most of the carpets with flowers made in that region are bordered around the perimeter and contained by straight lines. Inside the center, the artist weaves an ornament—also made from flowers—to enhance the border and harmoniously connect with its colorways. This ornament, also called a "medallion," is most often in an oval shape and sized in harmony with the size of the carpet. Then the artist fills the area around the ornament in what some call the "field." The four corners of the field are designed and woven with a quarter of the medallion in each corner. So, one villager could imagine a design nine feet wide and twelve feet long with a foot-wide border all around and a medallion in the center that is quartered, with each quarter woven into the four inside corners of the border and also a woven field.

So we have the border, the four arched corners, the field, and the medallion. Along with the well-balanced design structure comes the actual knotting, with colors to make a garden. Now comes the overflowing talent of the villagers to create a virtual

garden to display in one's home and admire all year.

The rugmaker goes to work, choosing the colors and shapes and sizes of the would-be woven flowers. Remember that the weaver is looking at a blank space that is nine feet wide and twelve feet long and uploading in his brain the finished product of the flower garden. To him, each flower has to look three-dimensional so as to appear to be real. So the villager has in his mind to apply different shades of color on one flower and not to make any two flowers exactly the same. By doing that, he ensures that even someone with education and a high intellect will not be able to memorize and remember what the colors are and in which flowers they are placed in the carpet, even if they see it every day.

This is why when one walks in the room, the carpet will always give a new image. It is impossible to live with that carpet and upload it into one's brain and then go somewhere and download it, whether by drawing it or describing it. It's a true piece of art that will always give a new impression every time you walk into the room.

The villagers who wove these magnificent works of art possessed healthy bodies and healthy minds. Village life is a perfect example of man and nature expressing their natural respect for one other. Families in those villages enjoyed good lives because of the family members' closeness to each other. They may live in one room with a dirt floor, but then they weave a beautiful rug, or "kilim," to use for a floor cover. Because kilims are made with a very fine weave, the sand does not go through to the surface. It gets cold in the mountains so kilims are used as blankets. If someone owned a horse, it was also covered with a kilim.

The villagers make good use of their time. The families usually work in the field, planting or harvesting, and they cook outside on the fire; they eat together and tell stories at night. A village is sometimes made of a hundred families that are living the same way. Usually the village elders with their wisdom resolve all village issues, such as disagreements on the price of a horse and so on.

The protocol for marriage is first that the boy is of mature age, usually eighteen. His mother makes the connection with another mother, one whose daughter the boy's mother thinks is good for her son. Then the fathers are notified, and they usually have silent approval. A few men from each family, usually elders,

will meet to discuss the dowry. It could be ten sheep from the boy's father to the girl's father. After the agreement, they plan the engagement. Usually the father of the bride will be at his home, already preparing for the party, when the family of the groom gathers and walks to the girl's home to ask for her hand. That group would be dressed in their most colorful embroidered clothing. It looks like a color feast, just a burst of colorful energy.

The girl's family is waiting, wearing the same colorful clothing. The elders sit opposite each other, and the boy's family elder asks the girl's family elder to bless the occasion and say that they would be honored if the girl's father would accept their request. Once the girl's father says yes, then the festivities start. The whole village erupts in colorful singing and dancing and eating. Once the celebrating is over, everybody goes home and the planning starts for the wedding, when the same festivities take place, this time at the boy's father's home.

I remember a wedding in Ramallah, how the people accompanying the wedding party wore colorful, embroidered flowing dresses and headscarves. Such bright colors—red, gold, green, light blue on black dresses—a burst of color on beautiful healthy faces. It was a party worth remembering.

It is a very joyful occasion because a new life will eventually be born, and there is nothing in the world as joyful to the village as a newborn. When the time comes, a midwife usually delivers the baby and the mother is cared for by the midwife for a short period of time.

The artistic creative talent for weaving was alive and well in the Caucasus Mountains in the 1800s and early 1900s, and it was passed from one generation to the next. With the onset of industrialization and with every new generation following, part of that talent has gone dormant. Gone is the villager who uses the natural products of his land, who cultivates the wool and the natural ingredients and spends five years weaving and hand-knotting a room-size rug that smiles at you and offers you a new image every time you walk in the room.

Full of energy and life, these true forms of art were recognized by people with high intellect from the industrial world. The carpets woven by these villagers are still among us, as they have a life span

of more than a hundred years if they are maintained properly. They are the largest piece of art in a home, one that can be felt and touched and enjoyed. As they age, these carpets acquire new, enhanced appearance as the type of wool and the vegetable dyes create a patina after years of exposure to ultraviolet light.

That is one reason people do not tire of their looks—also because the carpets were woven so creatively that they appear three-dimensional. It's a pity that the weavers are no longer alive to see the artwork they created being admired by the most intellectual people in the world—that enhancing the finest and most elegant decorating schemes are what was conceived and woven in a village thousands of miles away with a primitive culture.

We are fortunate to be able to own and use these carpets because they reflect talent and creativity, which become the hallmarks of one's home. The carpets become dominant in one's home because they have the energy to greet you every time you walk in that room. But that's only half of the picture. The other half is once a homeowner experiences the beauty and elegance of that carpet, they want to be surrounded with other furnishings made by talented artists. Paintings, statues, wooden furniture, a piano,

artifacts—that reflects talent. In homes filled with such items, people seem to make a new discovery every time they walk in a room.

That scheme of decorating is the ultimate in home-life, the most stimulating and enduring. Imagine a room with Persian carpets on the floor, leather furniture, artwork on the walls, and sitting by the fire reading a book with snowflakes coming down outside—all creating a very artful and peaceful environment.

The sky is the limit for other decorative schemes. People see a picture in a magazine that at first sight looks good, but it's all in one plane and easy to remember, like looking at wallpaper. In contrast, the complex and three-dimensional artwork of the hand-worked rugs is too complex for the brain to remember in detail. You have to go back and look again, and you will find you always have a new discovery that you have not seen before. Once you live in a room full of talent, you find it's like a banquet for one's brain and nourishment for one's heart and soul. Being surrounded by the product of such talent is like enjoying a dessert for a good life.

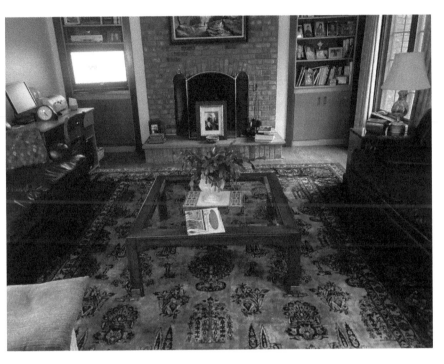

Carpets have the energy to greet you every time
you walk into a room.

The style of home furnishing and decoration in the United States changed after the Second World War. Until then it was colonial design for the exterior, with provincial furniture inside, whether French, Italian, or Chippendale (from England). Handmade carpets were placed on the floor to harmonize the furniture and wallpaper. It was a thoughtful way of decorating and furnishing because the intent was to sit around the fireplace and enjoy the décor, mostly earth tones and the colors of nature. This was a very comfortable scheme, because at that time the style of the homes and their furnishings was more architectural than it is today. Then, in about 1960, the broadloom carpet was invented, with many colors to choose from—and people were enchanted by it. Luxurious to walk on and easy to vacuum, these carpets could cover the whole floor, wall to wall, and people could avoid cleaning and polishing the wood surrounding the area rugs. Broadloom carpet also changed the look of a room by making it seem larger. So, people gave up their Persian carpets for wall-to-wall carpeting.

At that time, part of our business was installing wall-to-wall carpeting, so we were in the position to acquire the cast-off Persian rugs. We cleaned and warehoused them, believing in years to come the rugs

would be in demand. We still have some rugs from this time in our possession today.

Old rugs acquire a patina from ultraviolet light that beautifies the general impression of those carpets. In time, the people who wove these rugs moved on, and the new generation are not into the weaving; they are more interested in computers and the sciences. So after a while the old, artful carpets become a precious form of art—not just to look at but also to use.

In the 1980s, the carpet market shifted again from wall-to-wall carpet to newly produced carpets from India, China, Pakistan, and Turkey. These carpets are made with designs that were inspired by the Persian carpets but simpler and made for profit. They have designs and colors that the manufacturers coordinate with modern furniture, wallpaper, paint, etc. They have a simpler look than the old carpets and people liked that. Beyond the year 2000, the market for rugs in home furnishings became mixed. Some wall-to-wall, some handmade from India and China,

and some old Persian carpets. The new handmade ones are good quality, but the old Persian carpets have architectural poetry, and people who buy them are enchanted by their features.

When it comes to home furnishing, the hand-knotted carpets, new and old, are underpriced for what they offer the consumer. New carpets should last at least eighty years with proper care and cleaning in a residential setting. The consumer will enjoy elegant, comfortable, and warm tones to live with, and having many different colors in one rug gives the homeowner the chance to redecorate with a different color scheme and give the home a new look many times over.

Antique rugs in a home rule supreme because of the way they were designed, colored, and woven. They are true art pieces made to cover your floor and come up to greet the homeowner, emanating energy. They are more expensive than the new ones, but it's all relative. The antique rugs have had years of exposure to ultraviolet light, which creates the patina that makes them special works of art. This usually makes them more valuable because that cannot be reproduced.

The initial investment might seem high, but if one calculates the pleasure of owning these artful rugs—as well as the impact on children exposed to an

environment of elegance with talented, high-quality furnishings kept in the family one generation after another—it would be difficult to put a value in monetary terms. The number of antique Persian carpets is limited to the number of carpets that were woven in that part of the world in that period of time. Those carpets are the true collectables, as they are works of art that people with artistic intellect will react to. Those people appreciate talent and most likely are talented people themselves, and they want to be surrounded by quality furnishings and accessories and experience joy in what they live with and see.

To live one's life and have one's children grow up in such an environment would be the ultimate in human value and the epitome of goodness. And part of this surrounding beauty are those pieces of elegant art on the floor that one can treasure for a lifetime and then pass on to the next generation.

In time, the carpets I describe will be bought and sold from people to people by the square inch; that is how valuable they will be. Those carpets are not made anymore. In terms of artistic value, old Persian carpets should be put aside in one category and not be confused with new ones. The new rugs are made in a way to maximize production and to increase profit. It is a commercial business deal, so they eliminate many

colors and use the basics to copy the designs of the originals. They lack the artistic energy and the complexity of the originals, but of course the originals are not there to be compared with, so at their visual level they look acceptable. They are made with light colors on a light ground, so it looks like they were designed by an artist, but basically they are on one plain colorway and sit on the floor quiet. And some new rugs are very quiet so as to harmonize the colors on the wall and furniture surrounding. This is meant to give the consumer the ease by which to decorate a room because everything is on a plain dimension.

Socializing in the home is also not as common as it used to be. The social custom of friends and family visiting and sitting in a semicircle, debating the events of the day face-to-face—all the while viewing the artwork on the wall and artful carpet on the floor—has faded away.

Manufacturers of fabrics for furniture upholstery and wallpaper color schemes use tones that change every few years. With the onset of the internet, home

décor is changing to color schemes and furniture quality that is transient as the culture's creativity is shifting from the arts to the computer sciences. People are excited by the internet to a point where husband and wife communicate by texting each other in the same room! But to me, the home that is full of talented art makes for better living and a good way to prolong one's life. It stimulates the brain to be surrounded with talent.

I see a cultural change brought on by the internet. It has swung home furnishings in a simple, plain decoration. This simple environment will not stimulate the brain nor challenge it. If one looks at a display of commercial furniture, wallpaper, and machine-made rugs, one will see that there is no energy or soul in them versus the authentic old handmade Persian carpets. This scheme will sit dormant until the house can again be turned into a home. In today's culture, with the onset of the internet, people are immersed with the part of the brain that is science, and they have left the creative part somewhat dormant. But the creative part of the brain is what makes a good life. What is important is empathy, the joy when babies are born and life blossoms, and human emotions, whether it's joy or sadness, where the heart and soul are an integral part.

The Uniqueness of Ramallah and Its People

Ramallah in 1920 was 3,000 people—Christians who were inter-related in harmony with the natural elements. People were self-taught to plant vegetable gardens; my father and uncles built almost all the stone houses in town. Olive trees and fig trees were thriving in that climate. We walked to school and everywhere. It was a very healthy environment.

Immigration to the United States started in the late 1800s and continued steadily until almost all those Ramallah people had moved to America, scattered all over the fifty states and growing to a population above 85,000. In the U.S. they took advantage of the American way of life: the civil laws, the higher education institutions, the free enterprise system, and so forth. So some are highly educated, some went into small businesses, some took to trades, and they never became a burden of the government for assistance.

The main thing is that they are a very proud people, industrious and loyal. Even though scattered across the country, they never lost the instinct of a true family.

From the original 3,000 Ramallah residents of 1920, there are now around 85,000 people residing in the United States, living in every state in the union. Although each family settled in a place, they never lost touch with one another, connecting on a regular basis and also staying in touch with the few hundred who stayed in Ramallah.

In 1959, these expats formed an entity called the American Federation of Ramallah, Palestine, and *Hathihe Ramallah Magazine,* or *Ramallah,* was born. In each state, the former Ramallah residents formed social clubs to hold regular get-togethers, and before too long the cluster of Ramallah people in each state elected a president and a board of directors and appointed a reporter who communicates to the editor of *Ramallah* all the social and practical news about the Ramallah communities in that state. Twenty-two

correspondents submit information relating to the Ramallah community they live in—social information or actuarial—including names and pictures of college graduates, recipes, editorials, and so on.

The monthly publication is a high-quality magazine with interesting articles on different subjects, plus news of the Ramallah people all across America from each club's correspondent. It is a very interesting publication funded by donations from the Ramallah people.

With upward of 85,000 people scattered across fifty states who are directly related to this small town, and with a directory of names, addresses, phone numbers, etc., we can continue to communicate with each other. For people from villages like Ramallah, the connection to cultural ties and emotions runs deep, and keeping in touch, even from afar, allows us to feel closeness to each other.

So the Ramallah community is spread over fifty states but still connected and growing. Our food menu in Ramallah was brought with us to the United States. In origin, some dishes such as falafel came to us from India, but whereas in India they used lentils for the main ingredient in falafel, we use chickpeas, with the same spices. Our meatballs originated in Armenia, where small amounts of meat are mixed

with onion, breadcrumbs, parsley, and spices in tomato sauce; this would feed a family and it is tasty. We also do the Kibbi, a famous dish that came to us from Lebanon. All these recipes were brought with us to the United States, and they have continued to be enhanced upon here.

In 1959, a new idea was born. Why not have Ramallah people get together and socialize once a year in the summer? They called this the Ramallah Convention, and it is sponsored and organized by a different local Ramallah club each year to give people a week's time to explore and visit, socialize, and connect in that community (a lot of marriages have been initiated at the convention as well). Usually a few thousand people show up, so the local club rents the largest hotel in town to accommodate the visitors. This gives a taste of Ramallah the village—the culture, the music, the food, all are abundant—every year. Young and old attend, meeting each other as if they are in Ramallah. To my knowledge it has never happened in the history of the United States to have those who have immigrated to the U.S. from a small town such as Ramallah gather this way year after year.

So we have the convention, the telephone directory with addresses, and a monthly publication that is mailed to every Ramallah household in America.

There is a donation paid by every Ramallah family every year, and some donations are sent to the main office of the Ramallah Federation.

Kaoud Rugs is a dominant name in the state of Connecticut. After sixty years of service to the community, we are known for high quality and service. I am fortunate to be an American and share in the American experiment. America is designed for people who work and produce.

So here in the best country on the planet, with the best form of government, with the most educated people and the best universities, here we are offering for sale the most talented form of art. Visually it is the largest form because it is displayed on the floor and its energy reaches out every time someone walks into the room. Then one can touch it, feel it, sit over it, and visually consume it.

The most amazing part of my experience in handling these carpets is how a university professor cannot get enough enjoyment from a piece of artful carpet that was conceived, designed, colored, and woven by

a villager, someone who never had any schooling or experienced any civilization outside his village. But that's only half of the picture. I asked a professor to look at one of his carpets, to study it all he could, upload the image into his brain, turn around, and try to download it onto a piece of paper. No way could he do that. Nor can anyone.

It is amazing how a villager with only the creative part of his brain, without any computer or other tool, can make this complex artwork with the best material in the world. It is just sad that these villagers are not alive today to witness their work of art at its most majestic, as most of these carpets look their best with the patina formed between 70 and 120 years after they are made.

Today, one would be astounded by how those villagers would set up a loom cut from wood and harvest their own wool from their sheep. They would collect flowers, seeds, and roots and boil them with the wool to dye it in the colors they imagined would look good on the carpet. They would spin the wool in their primitive way, and from their creative talent imagine the design and the colors, all in the mind.

It's a compound, complex work of art and executed in a form that you make use of on the floor, where you can walk on it, touch it, feast your eyes on

it. When you walk out of the room and come back in, you will see a different impression, one that you have not seen before. It is a three-dimensional artwork yet lying flat on the floor. Oh, antique rugs, how great thou art. Kudos to those primitive architects who produced a product to last over a century for today's culture to experience.

I have enjoyed interaction with the highest intellects in the world. It has been an honor and a privilege for me, the boy from Ramallah, and I would be happy to do it all over again.

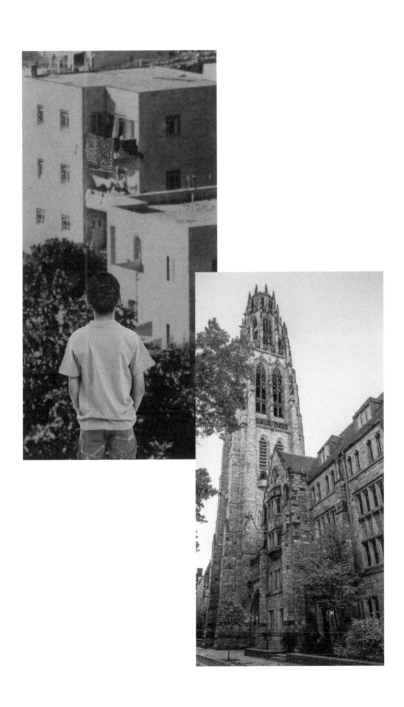

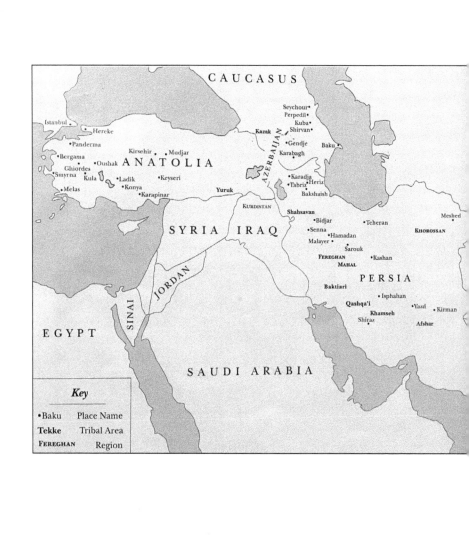

Rug
Gallery

A ntique rugs woven in far-away villages were brought to the United States in the 19th century. In fact you could say they were made here. as they were used here and exposed to the light here, gradually changing color and texture, creating a patina and enhancing the color as the pile wears down. At the bottom of the pile are the wool knots that reflect a beautiful color because the sides of the yarn is reflective. So it appears that the pattern is clearer and the angular shapes are sharper and architecturally artful.

Agra (India)
circa 1890
9 ft. 9 in. x 11 ft. 9 in.

The black ground color is designed to recede
so that the flower field—with all its detail—rises.
The border has an impressive soft green shade
that gives prominence to the clusters
of flowers in the field.

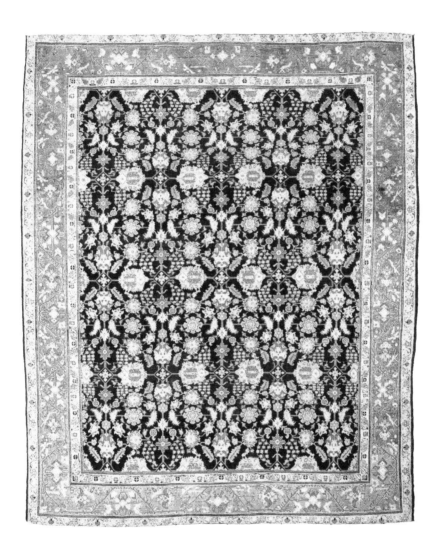

Keshan
circa 1900
4 ft. 2 in. x 6 ft. 7 in.

The finest example of a Persian Keshan Kurk
wool vase design, this rug is conceptually superior
for its amount of detail and color distribution.

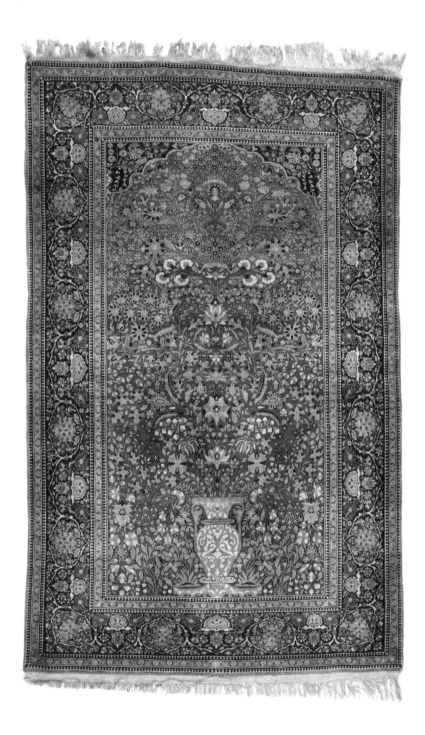

Persian Seychour
circa 1870
3 ft. 4 in. x 5 ft. 3 in.

This is pure villager art, with design and color
conceived in the heart of a creative artist,
not knowing what it would look like after woven.

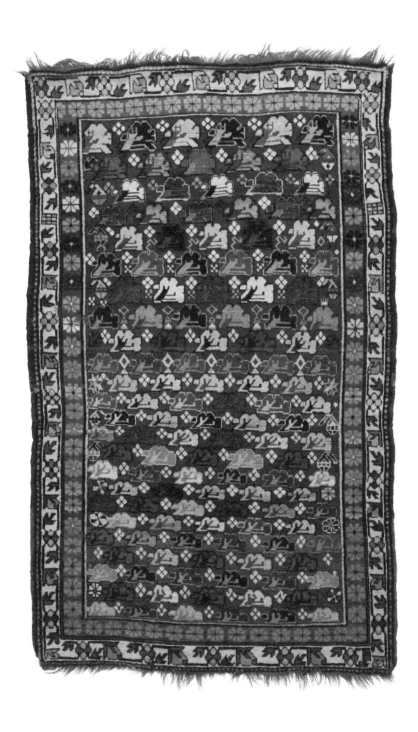

Persian Tabriz
circa 1880
4 ft. 1 in. x 5 ft. 7 in.

"Art is the only way to run away
without leaving home."
—Twyla Tharp

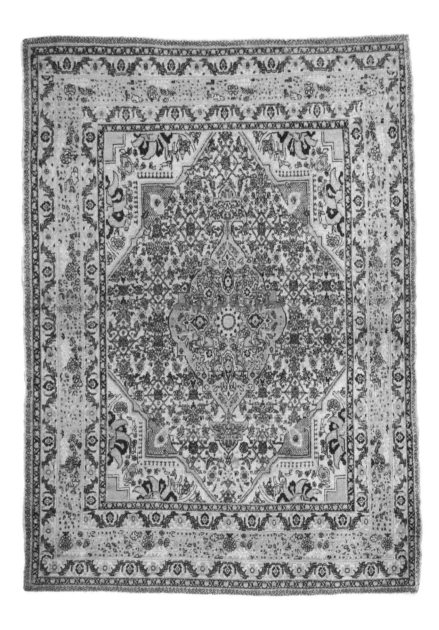

Persian Eagle Kazak
circa 1900
4 ft. 8 in. x 9 ft. 2 in.

This majestic Eagle Kazak rug has complex
architectural appointments.

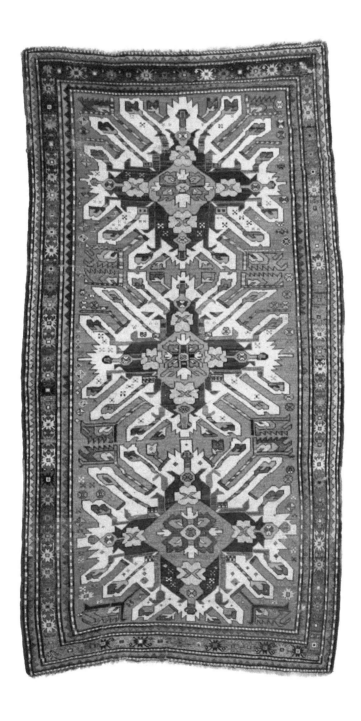

Persian Senneh
circa 1880
4 ft. 6 in. x 6 ft. 3 in.

This magnificent and detailed piece of art
was conceived by a highly creative villager
and designed with interlocking medallions.

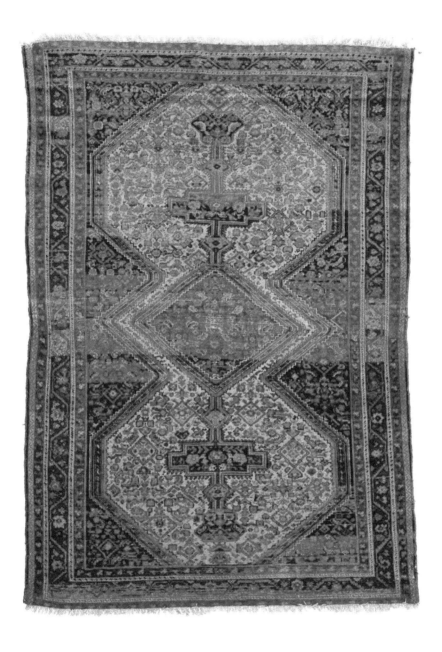

Persian Tabriz Prayer Rug
circa 1900
4 ft. x 6 ft.

A prayer rug with a beautiful dome.

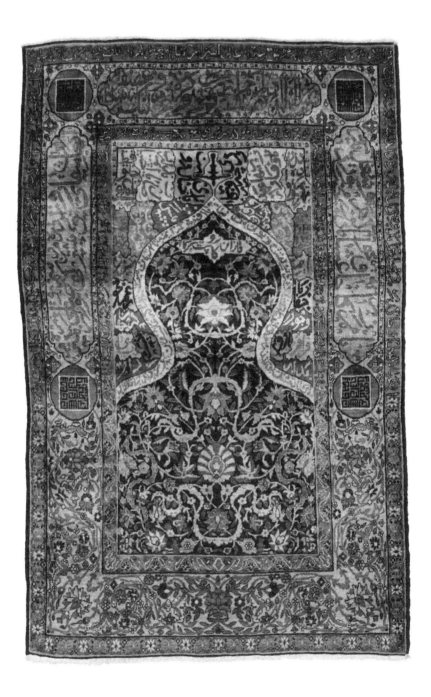

Persian Shirvan
circa 1890
3 ft. 6 in. x 4 ft. 8 in.

This fine example of a prayer rug is tightly woven
with a low pile for use on the ground when praying.

"The job of the artist is always
to deepen the mystery."
—Francis Bacon

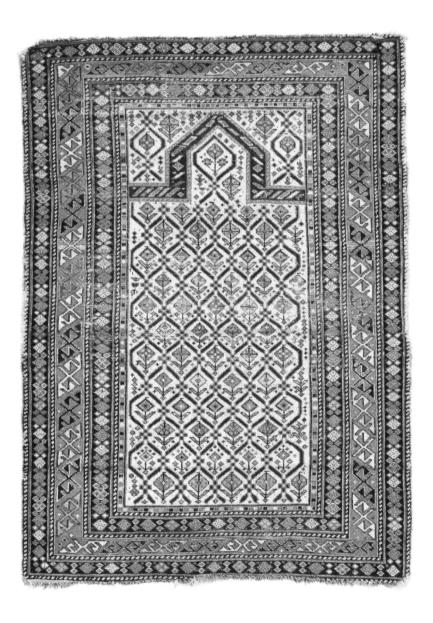

Persian Serapi
circa 1900
9 ft. 7 in. x 12 ft.

"Great art picks up where nature ends."
—Marc Chagall

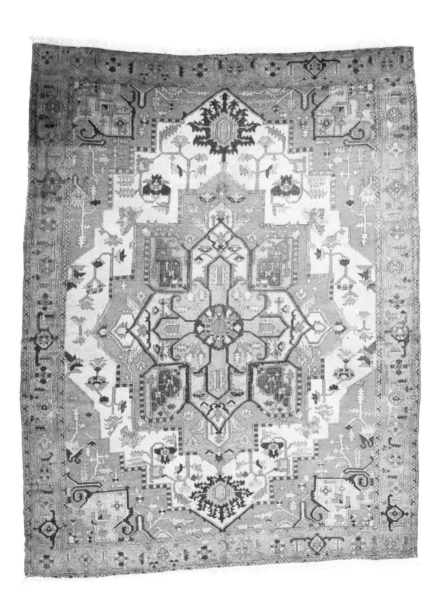

Persian Tabriz
circa 1870
10 ft. 3 in. x 15 ft. 8 in.

This is a fine example of an unusual color design combined with a highly detailed, disciplined pattern that is well balanced. This oversize rug was made in a village 150 years ago.

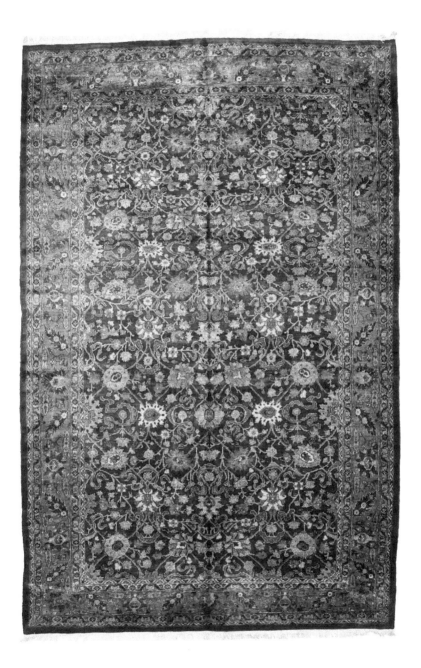

Persian Kermanshah
circa 1880
10 ft. 11 in. x 17 ft. 1 in.

"Life beats down and crushes the soul
and art reminds you that you have one."
—Stella Adler

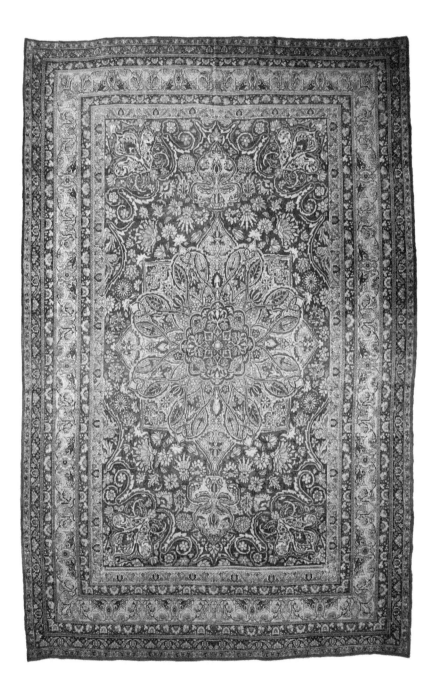

Lavar Kerman
circa 1880
12 ft. 9 in. x 21 ft. 9 in.

"To send light into the darkness of
men's hearts—such is the duty of the artist."
—Robert Schumann

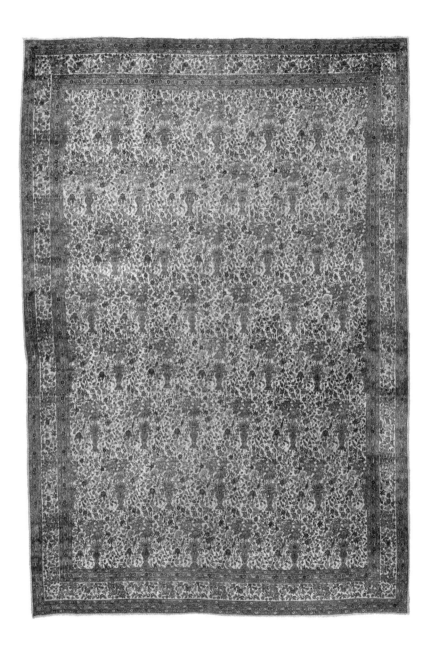

Persian Sarouk
circa 1920
9 ft. x 12 ft.

This rug provides a flower garden that is
pleasing all year long.

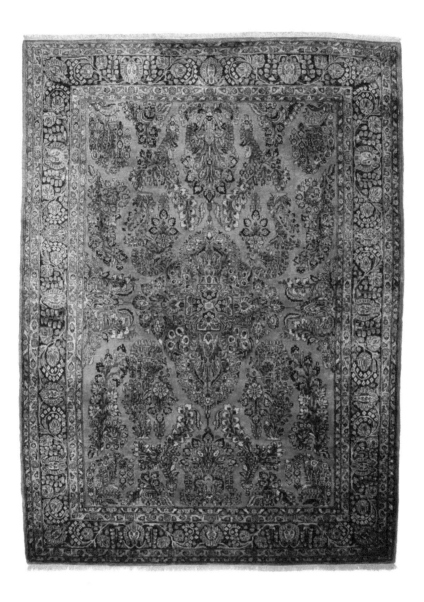

Peking (China)
circa 1920
9 ft. x 11 ft. 8 in.

Classic Peking design of delicate sprays of
flowers scattered throughout in a good
balance of color and design.

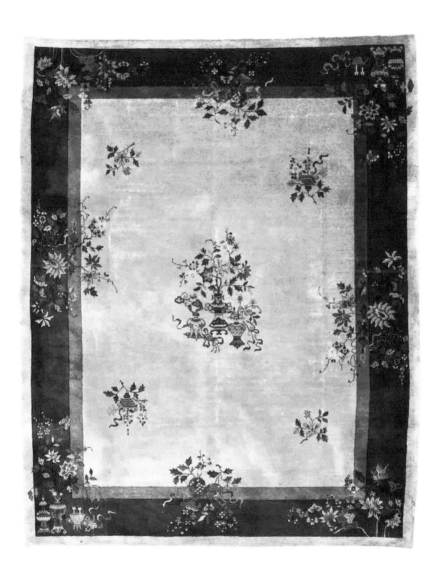

Persian Faraghan
circa 1870
4 ft. x 6 ft.

This is a shining example of fine weaving,
color, and design conceived and woven
by a villager.

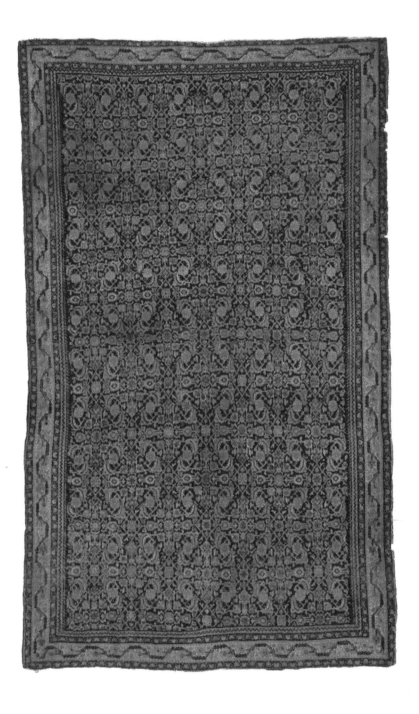

Kazak
circa 1850
4 ft. x 6 ft.

For such a small size, this rug is loaded with
architectural elements; it is surrounded
with a magnificent triple border.

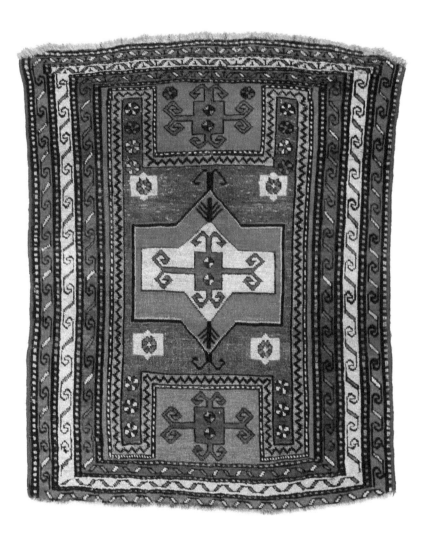

Persian Kerman
circa 1930
9 ft. x 12 ft.

This typically highly detailed Kerman is like a
peaceful and well-balanced garden.

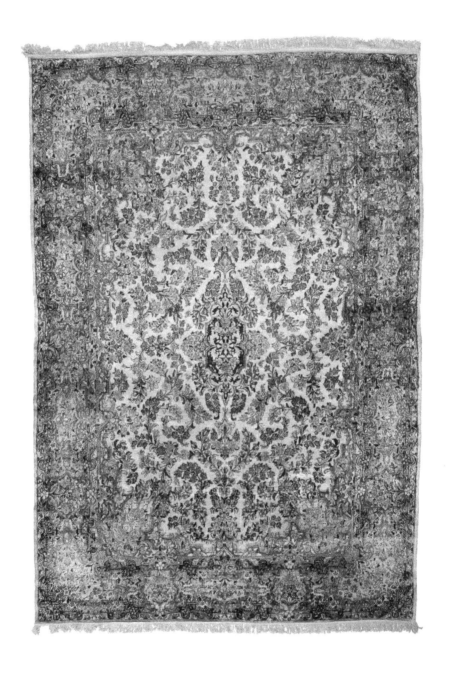

Persian Lavar Kerman
circa 1900
8 ft. 7 in. x 11 ft. 2 in.

This artistic and finely detailed old Kerman
was designed for people to warmly gather
around the center medallion.

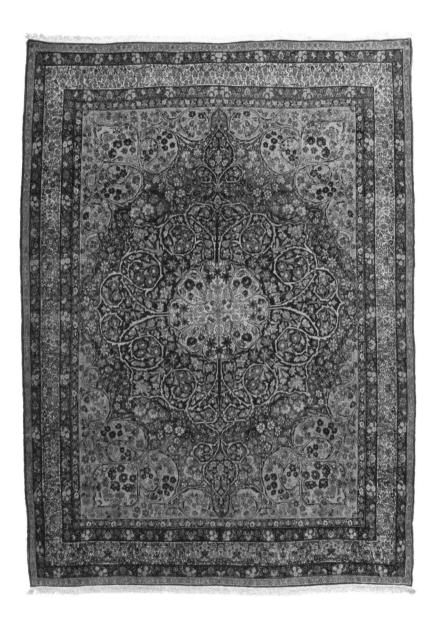

Persian Tabriz
circa 1870
8 ft. 8 in. x 12 ft. 9 in.

"The world of reality has its limits;
the world of imagination is boundless."
—Jean-Jacques Rousseau

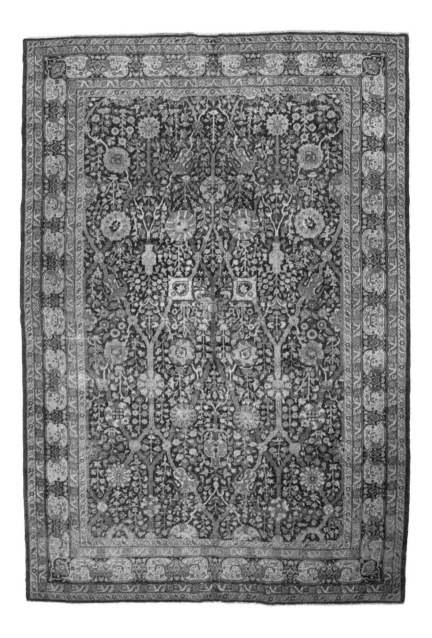

Persian Seychour
circa 1880
4 ft. 3 in. x 6 ft. 3 in.

"Without craftsmanship, inspiration is
a mere reed shaken in the wind."
—Johannes Brahms

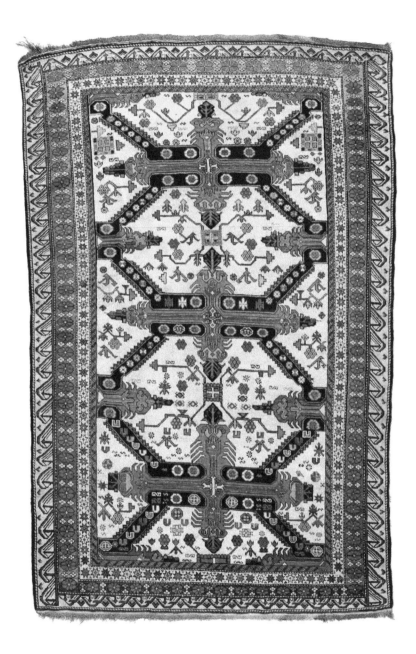

Persian Tabriz
circa 1870
11 ft. 3 in. x 18 ft.

Outstanding color combination,
peaceful and engaging—a simply magnificent
piece of art.

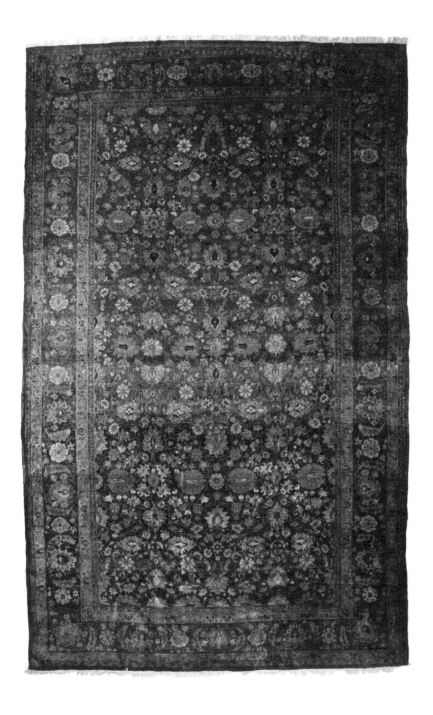

Persian Antique Kermanshah
circa 1900
8 ft., 10 in. x 12 ft., 11 in.

This rug is highly detailed with a
French Aubusson motif, offering
soothing colors with disciplined design.

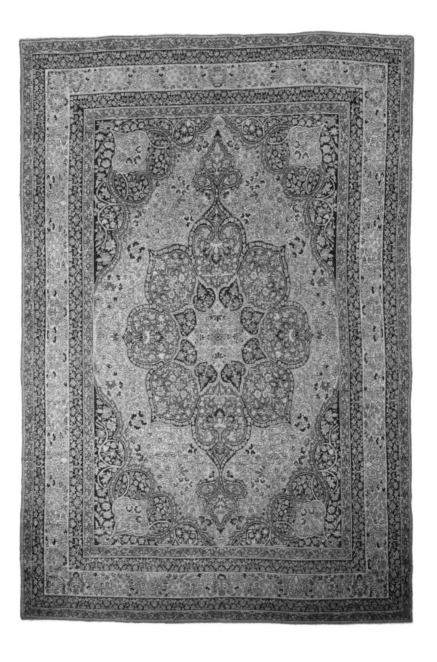

Antique Karabagh
circa 1860
4 ft. 4 in. x 7 ft. 8 in.

A masterpiece of geometry and architecture;
complex and magnificent.

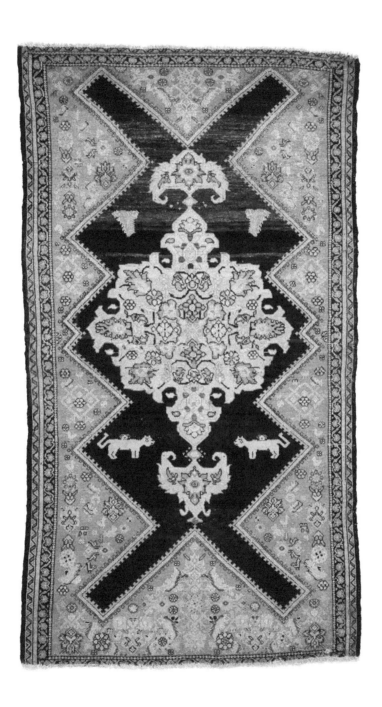

Antique Kazak
circa 1870
4 ft. 3 in. x 7 ft. 2 in.

Complex geometric stars in the night sky.

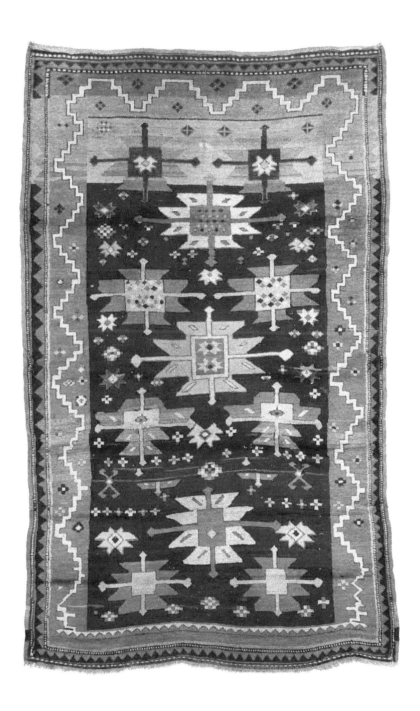

Chinese Art Deco
circa 1920
10 ft. x 14 ft. 6 in.

One hundred years old, electrified blossoms
yet extremely peaceful.

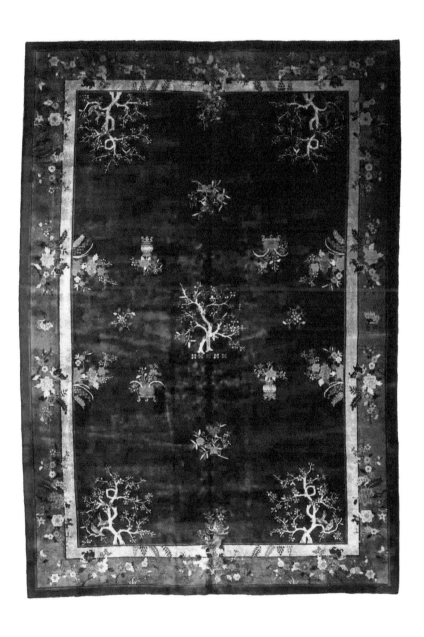

Persian Kerman
circa 1920
12 ft. 6 in. x 20 ft. 9 in.

Palace-sized and very welcoming, a color scheme
to enhance any décor.

Persian Heriz Rust Navy
circa 1910
11 ft. 9 in. x 19 ft. 2 in.

A masterpiece that is highly detailed,
palace-sized, and well balanced.
A true work of art.

Antique Persian Bidjar
circa 1900
5 ft. 3 in. x 7 ft. 9 in.

Primitive artistry, 120 years old.

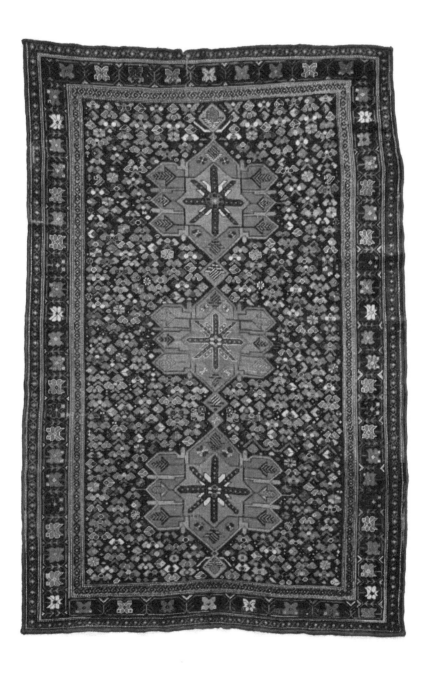

Persian Tabriz
circa 1940
8 ft. 5 in. x 10 ft. 7 in.

This classic Tabriz design has a
highly detailed artistic border balanced
with a talented medallion.

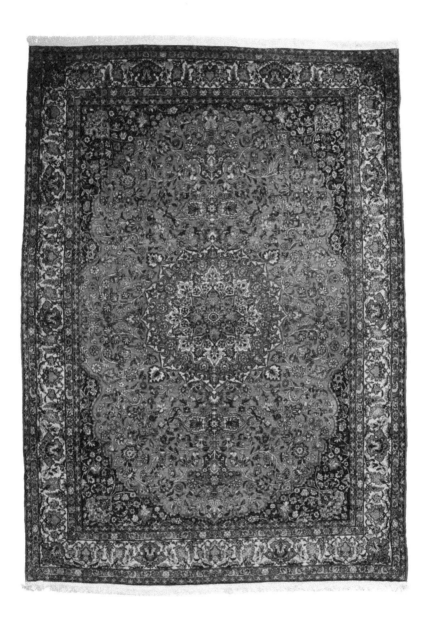

Turkish Oushak
circa 1890
6 ft. 11 in. x 15 ft. 4 in.

Colorful and simple, it will warm any
home environment.

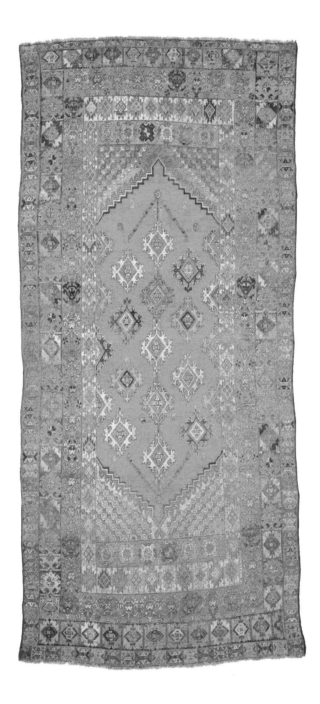

Chinese Art Deco
circa 1930
9 ft. x 11 ft. 3 in

A natural, peaceful scene from
the Chinese culture.

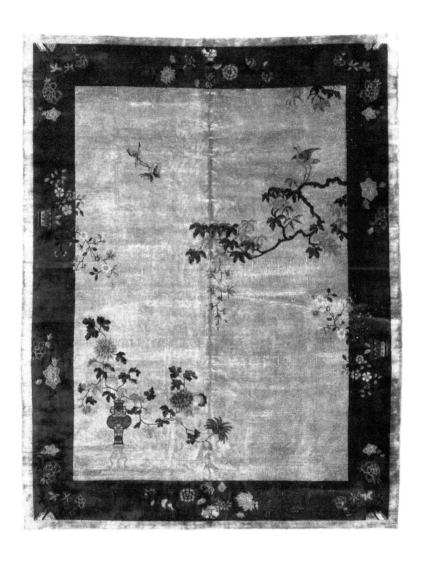

Persian Tabriz
circa 1930
10 ft., x 13 ft.

A welcoming jester with aqua-blue medallions
bringing it to life.

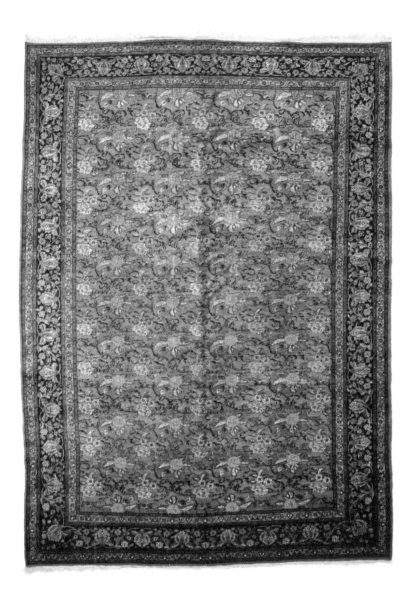

Antique Persian Faraghan
circa 1870
4 ft. x 6 ft.

Aged and very fine, this rug truly
belongs in a museum.

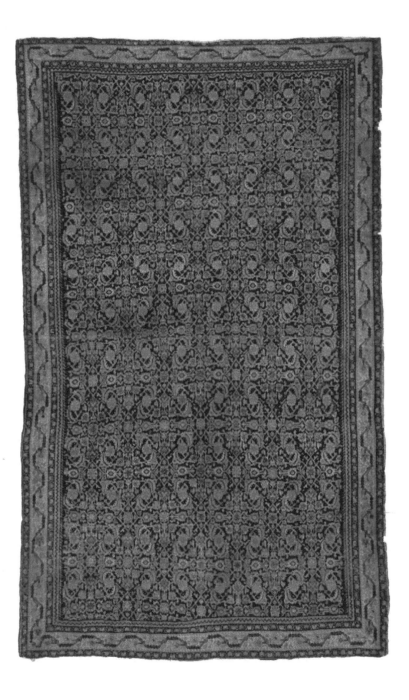

Antique Caucasian Chichi
circa 1870
3 ft. 4 in. x 8 ft. 8 in.

Architecturally magnificent, with superb
color choices.

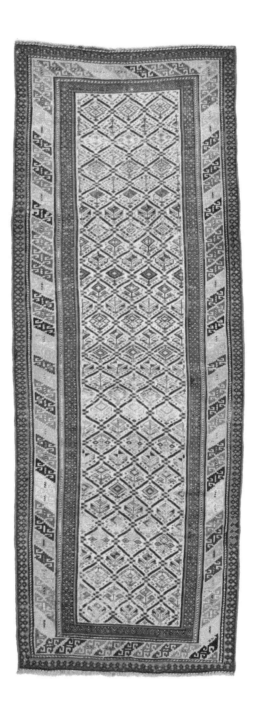

Acknowledgements

Thanks to my late brother Fred, and my brother Abe, for the time we shared in our early years working in the business. Thanks go to Margaret Kirby for her assistance and her ideas; and to Mary Norris, for her knowledge and professionalism.

About the Author

Rumzi Kaoud was born in Ramallah in 1938, where he grew up attending the Friends School, a private boarding academy sponsored by the Quakers. After graduating, he joined his family in New Haven, Connecticut, serving in the National Guard before beginning his career in antique and contemporary rugs.

CPSIA information can be obtained
at www.ICGtesting.com
Printed in the USA
BVHW051252110122
625748BV00001BA/2